at home

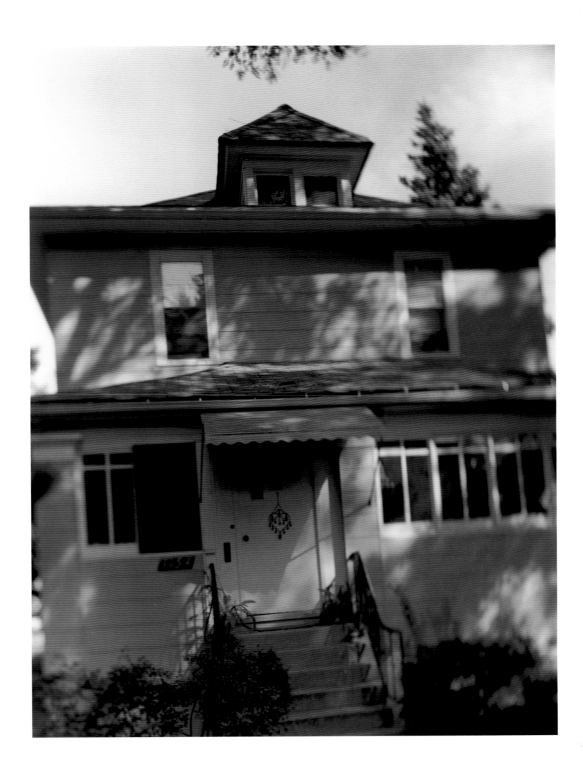

at home

by WILLIAM FREDERKING

WITH AN AFTERWORD BY BRANDY SAVARESE

CENTER FOR AMERICAN PLACES SANTA FE, NEW MEXICO, AND STAUNTON, VIRGINIA

IN ASSOCIATION WITH COLUMBIA COLLEGE CHICAGO

PUBLISHER'S NOTES: *At Home* is the eleventh volume in the series *Center Books on Chicago and Environs*, George F. Thompson, series founder and director. The book was brought to publication in an edition of 1,250 clothbound copies, with the generous support of Mark Kelly and Patricia Needham, Terri Reinartz, Columbia College Chicago, and the Friends of the Center for American Places, for which the publisher is most grateful. At Columbia College Chicago, thanks also to Dr. Warrick Carter, President; Steven Kapelke, Provost; Leonard Lehrer, Dean of the School of Fine and Performing Arts; and Michael DeSalle, Chief Financial Officer. For more information about the Center for American Places and the publication of *At Home*, please see pages 71–72.

Design by Colleen Plumb
www.colleenplumb.com

The Center for American Places, Inc.
P.O. Box 23225
Santa Fe, New Mexico 87502, U.S.A.
www.americanplaces.org

Distributed by the University of Chicago Press
www.press.uchicago.edu

9 8 7 6 5 4 3 2 1

Library of Congress Cataloging-in-Publication Data
is available from the publisher upon request.

ISBN 1-930066-30-9

for my family:

MY MOTHER, FATHER, SISTERS, AND BROTHERS;

MY WIFE, DONNA;

MY CHILDREN, JULIE AND DAVID.

contents

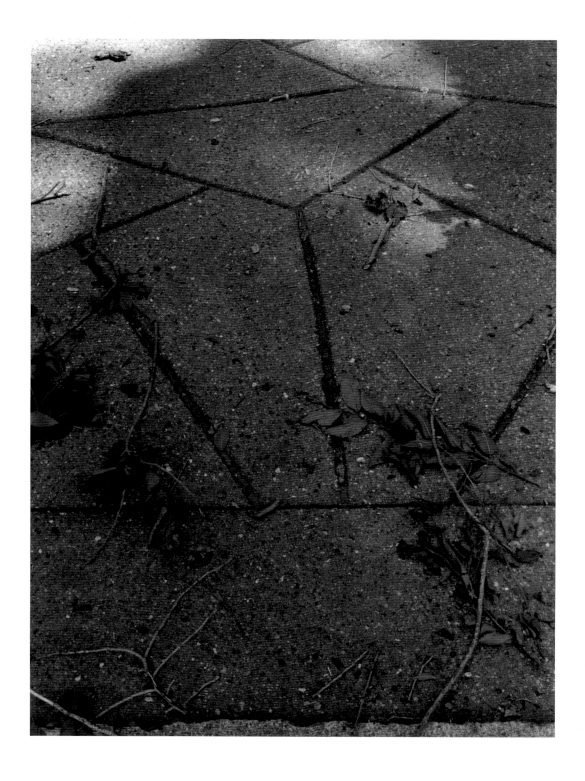

prologue: LIVING IN OAK PARK

My family and I live in a two-story, seven room, eighty-five-year-old house in a residential neighborhood on the southeast side of Oak Park, Illinois, one block west of the city limits of Chicago. Oak Park is a small, diverse community with tree-lined streets, sprawling Victorian homes, and acclaimed architecture by Frank Lloyd Wright. Our house, an American Foursquare, is located far to the south of the Victorians and the Frank Lloyd Wright treasures, on a block containing small, modest homes and several two-flat apartment buildings. It's a lively neighborhood, especially in summer, when the air is redolent with barbecued meat, the sounds of children playing well past dark, and the throbbing bass tones of music from slow-cruising cars.

The house was described in the real estate listing as a "Charming family home on a large lot. There is beautiful art glass, dining room has beautiful oak wainscoting with plate rail. Oak floors. Beamed DR ceiling. Appliances "as is." Enclosed front porch. Includes DR chest of drawers." On the day my children and I first visited the house with the realtor, we had already spent a long day looking at seven or eight houses in our price range, and we were running out of houses.

Strong, late afternoon sunlight washed the front of the dirty white house, welcoming us as we walked under the worn aluminum awning suspended above the front door by two metal rods crowned with spear tips. The realtor opened the door, and it stuck halfway due to the slant of the porch floor. The doorknob and lock on the oak and plate-glass door to the foyer were broken, but the agent found the key to open the deadbolt lock and then welcomed us in.

An old woman was sitting in a rocking chair in the living room, just to the right of the foyer. She was the owner of the house who had moved in

with her husband and teenage son in 1970. We exchanged greetings, and the agent chatted briefly with her about her children, grandchildren, and her health. My children and I just stood there, looking at the living room and dining room and the part of the kitchen that could be seen through the dining room door. As we were leaving to tour the rest of the house, the old woman turned and told me that, even though she had lost her husband six years ago, she had wonderful memories of all the family gatherings and good times they'd had in the house. "This is a good house," she said, "There is love in this house."

I had been divorced for two years and was living in exile in a one-bedroom apartment, one block away from my children and my former home. They visited me every other weekend, at first camping on futons on the living room floor and eventually sleeping on bunk beds. We were all tired of this arrangement and finally I felt ready to make a change. In spite of the water seepage in the basement, the small, dark kitchen with ancient appliances and no cabinets, the aged acoustical ceiling tiles and worn hardwood floors in the upstairs bedrooms, and

the moldy, red shag carpet and crumbling walls with pink plastic tiles falling all around in the bathroom, I bought the house, a month after first seeing it.

Almost immediately after we moved in, I began the process of literally rebuilding the house to remake it into our home. First to go were the shag carpet and the crumbling, pink-tiled walls in the bathroom; next went the acoustical ceiling tiles in the upstairs bedrooms; then the upstairs hardwood floors were sanded and finished. Finally, I tore out the walls and the old wiring in the kitchen and installed new wiring and appliances; I put up fresh drywall and laid a new, blue linoleum floor.

Shortly after completing the kitchen, I met and fell in love with Donna. After we decided to marry, suddenly the house seemed too small. During the final weeks leading up to our wedding, we hired a contractor to demolish part of the kitchen and add a twelve-foot addition to the back of the house. The structural addition to the house was nothing compared with the dramatic transformation the arrival of a new being and all her personal belongings brought to the

house that had once been occupied by only my children and me. I felt the process of home building that had begun when my children and I bought the house rose to a new and exciting level when Donna moved in and the four of us began the complicated process of building a new family together.

The first photographs I made of the house were "before" color snapshots to send to my mother and siblings and to document the old house at the start of remodeling. As the demolition proceeded, I began to notice the beauty of the light falling on the crumpled plaster and the partially gutted walls, and I decided to make a few photographs with my Deardorff 4x5 view camera on black-and-white sheet film. For several years prior to the purchase of the house, my photographs were all made in studios, with people and scheduling problems and artificial light. These new photographs helped me rediscover the joy I felt twenty years before, when I worked on a series of color photographs of everyday objects in the Chicago apartment that my ex-wife and I rented after

the birth of our first child. Working slowly and quietly, allowing time to notice the light on surfaces and objects and to compose thoughtfully, seemed like the perfect antidote to the fast-paced problem solving of the professional photography I was doing back then.

I continued to photograph the demolition and rebuilding process as one project ended and another began. Slowly, the objects left behind for us by the old woman were also included in the images. Over time, particularly after Donna moved into the house, I became more and more interested in how the accumulation of objects was transforming the character and meaning of the spaces in our home beyond the actual physical reconstruction of the house.

I came to understand that the memorable and mundane objects we continually surround ourselves with contribute greatly to the telling of the stories of our lives. So, when asked to describe these photographs, I say that, for me, they are about the changes in our lives as represented by the common objects we leave behind and the spaces that are altered by our presence.

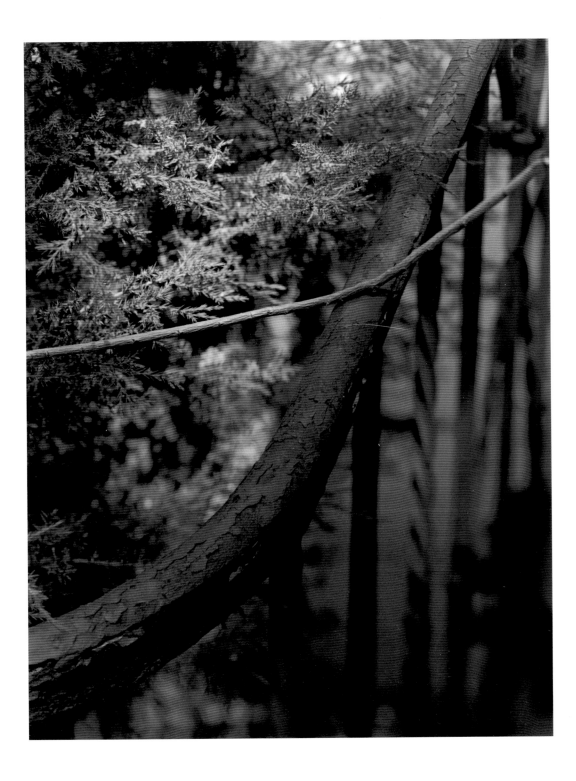

at home

"There is plenty of time. We may stand in front of it, and watch it, so long as it may please us to; watch its wood: move and be quiet among its rooms and meditate what the floor suggests, and what is on the walls, and what is on the shelves and tables, and hangs from nails, and is in boxes and in drawers: the properties, the relics of a human family, a human shelter."

james agee

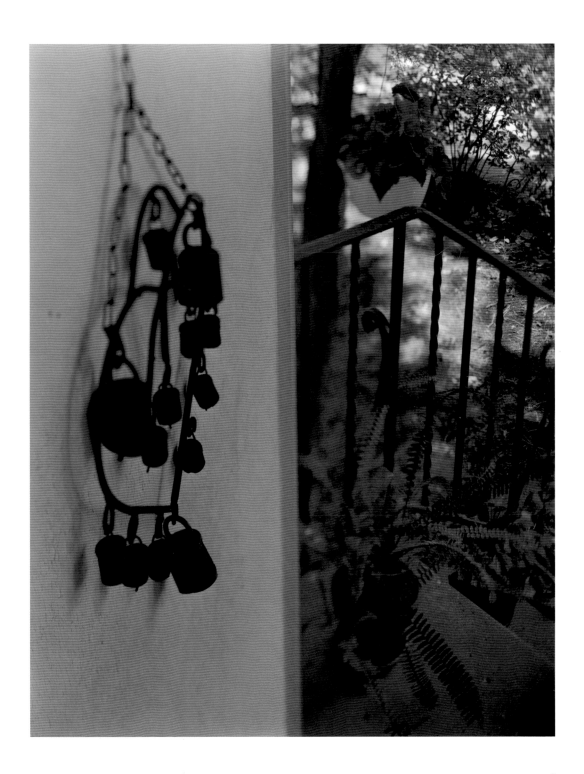

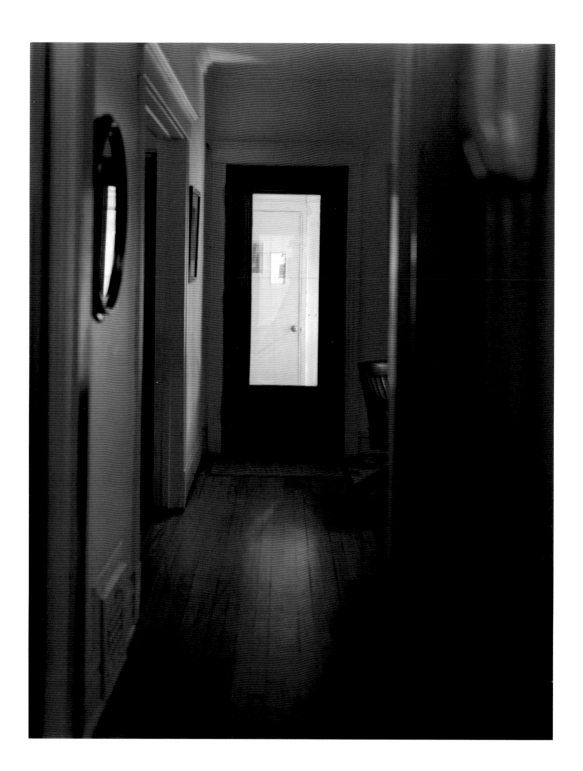

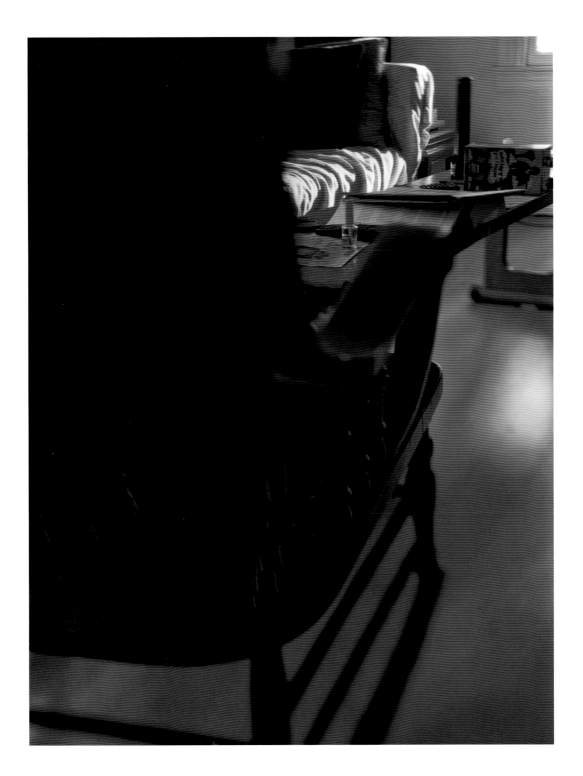

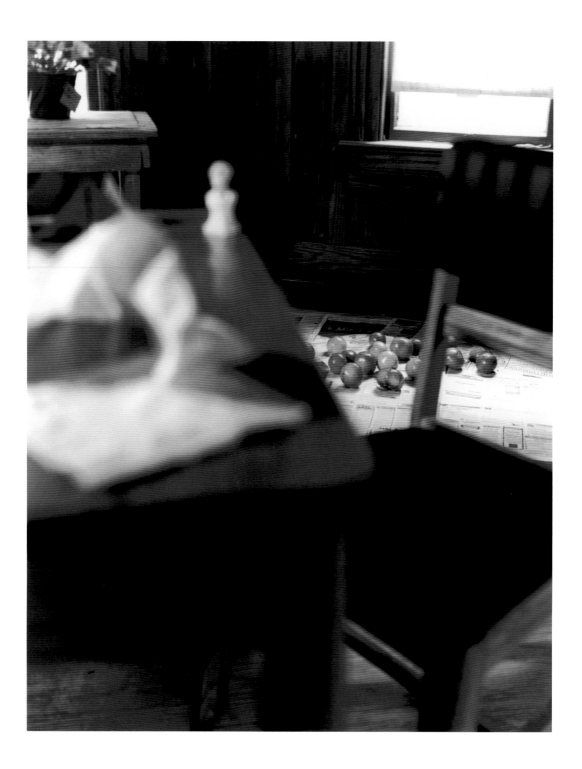

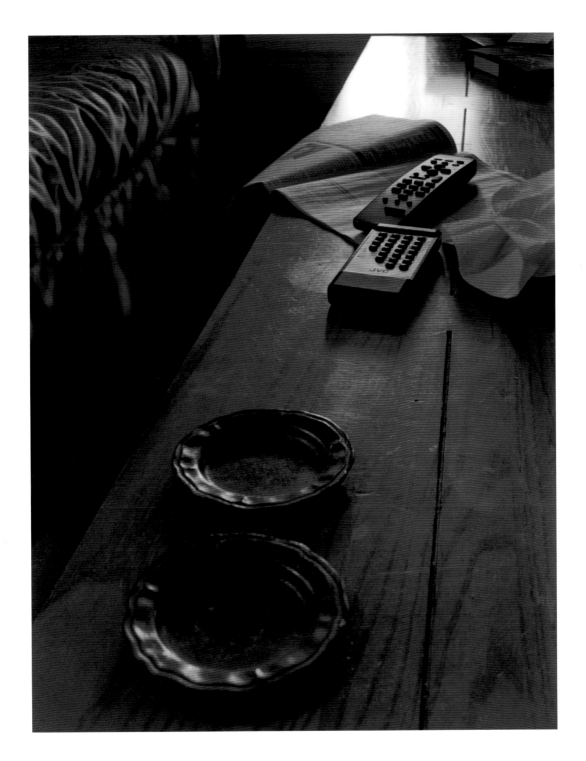

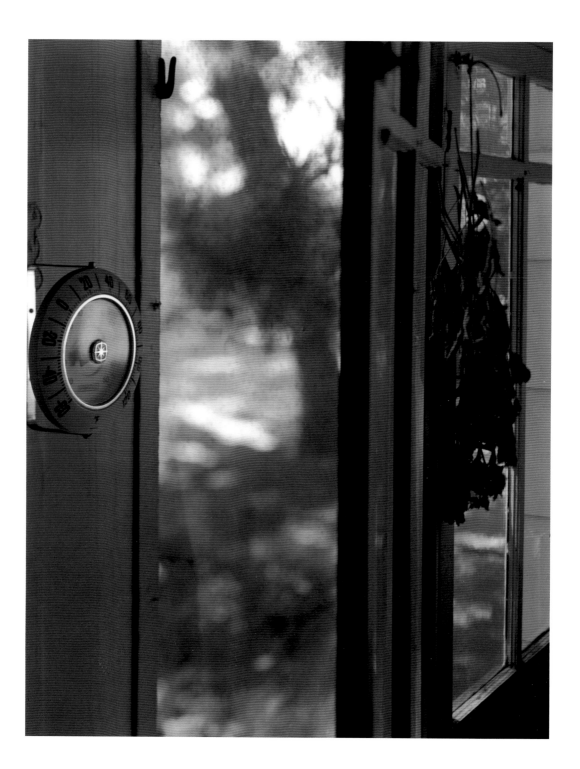

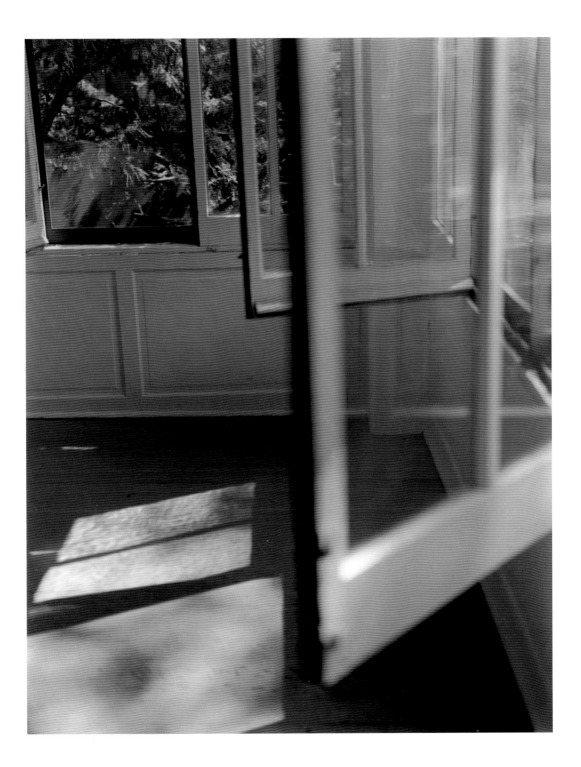

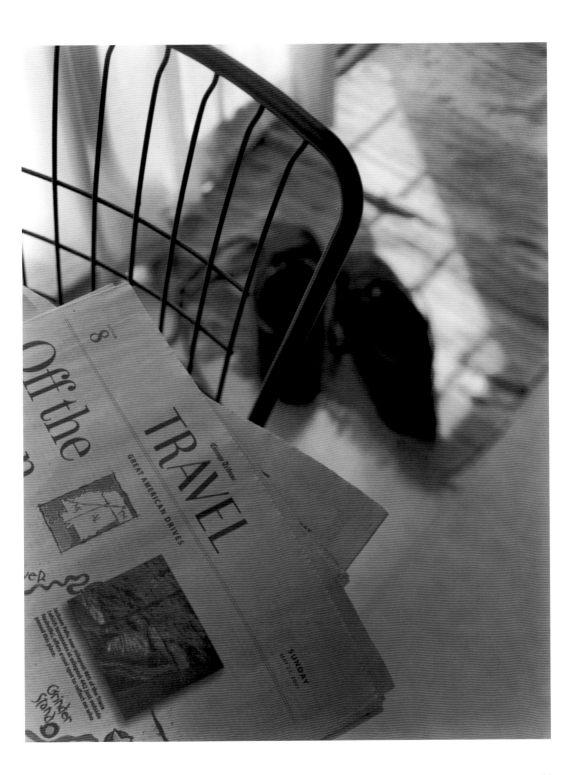

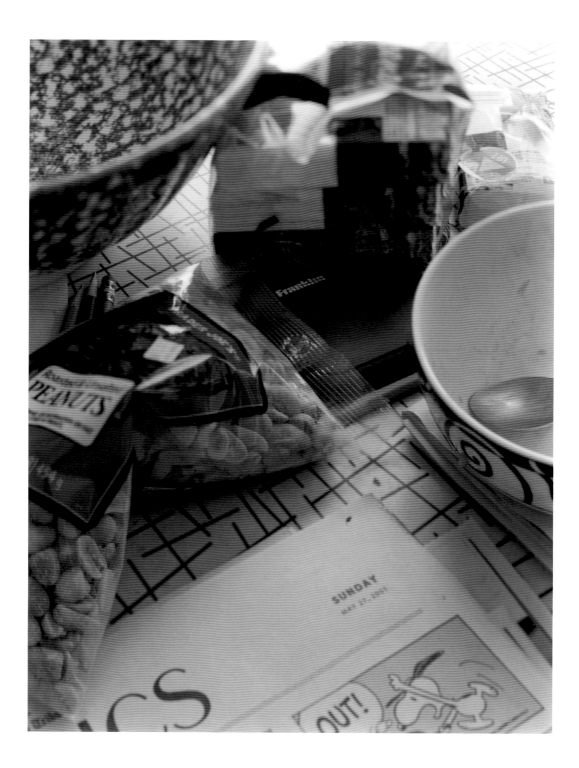

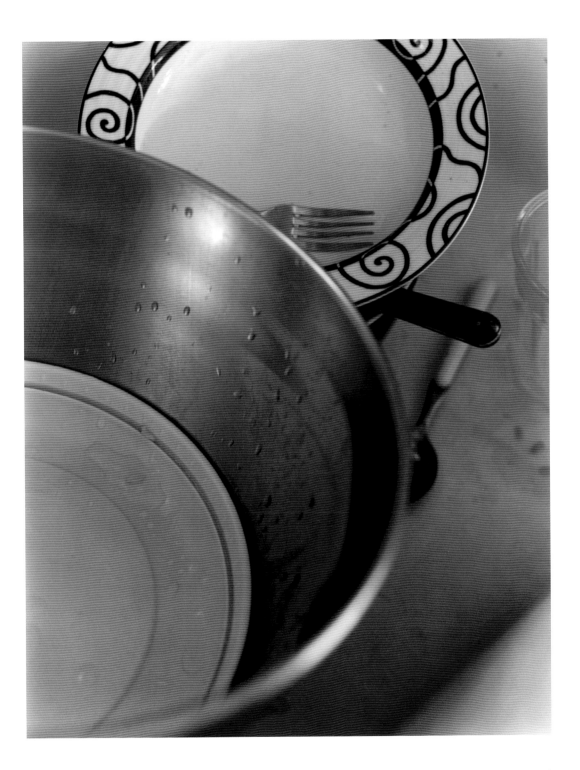

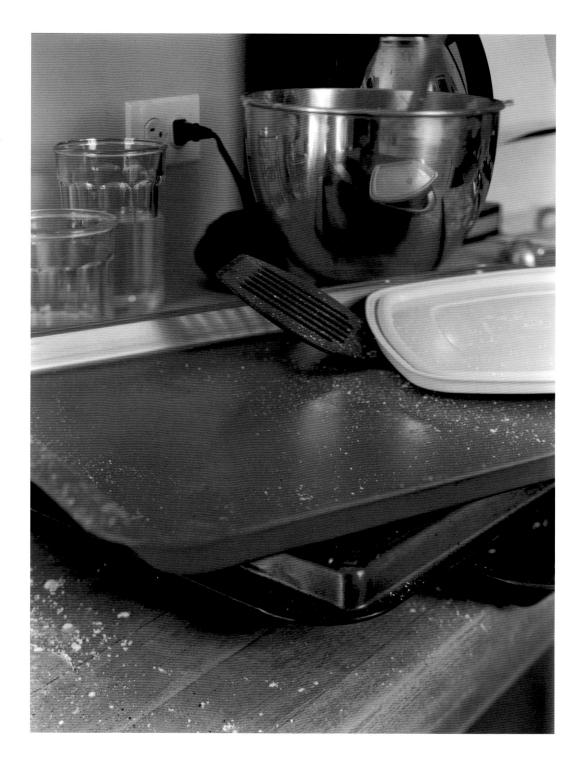

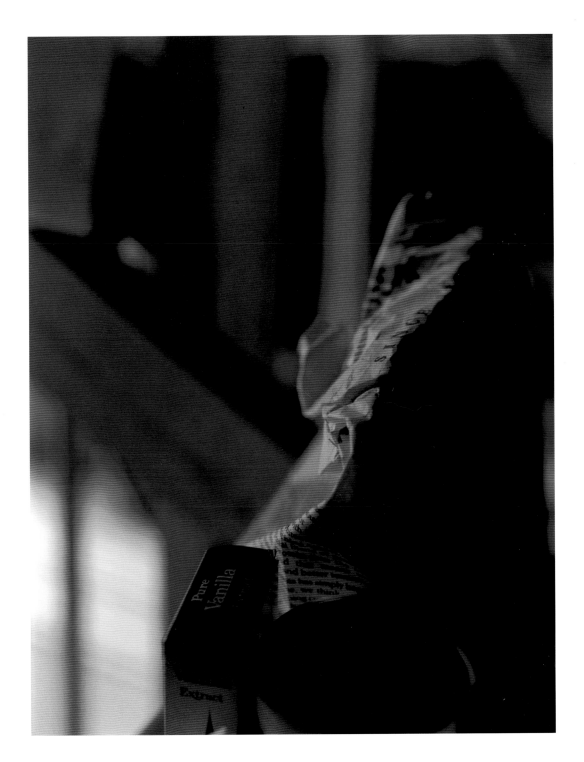

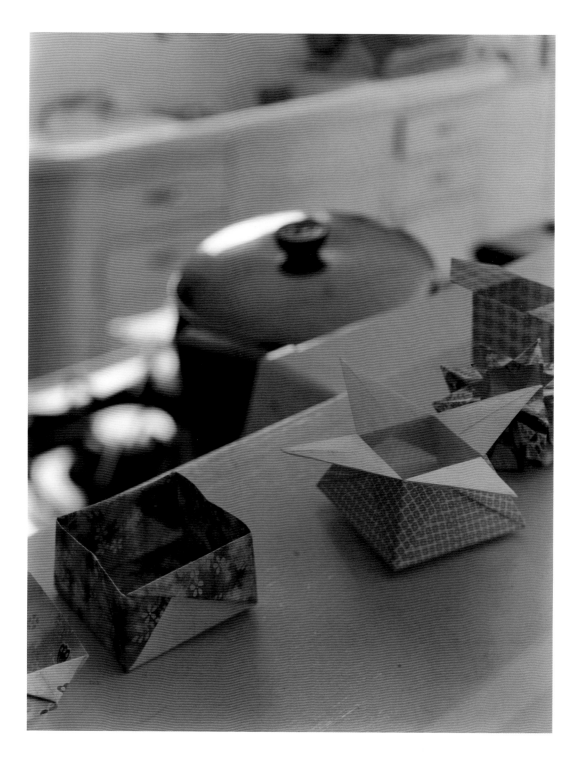

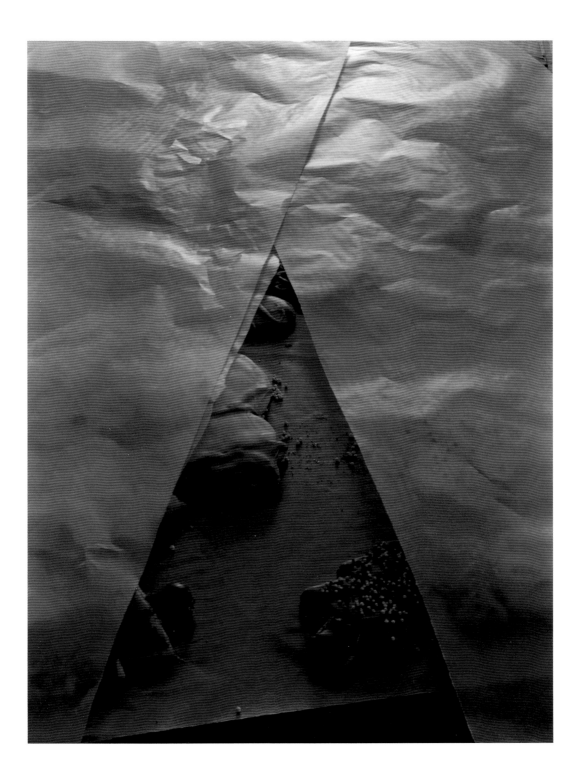

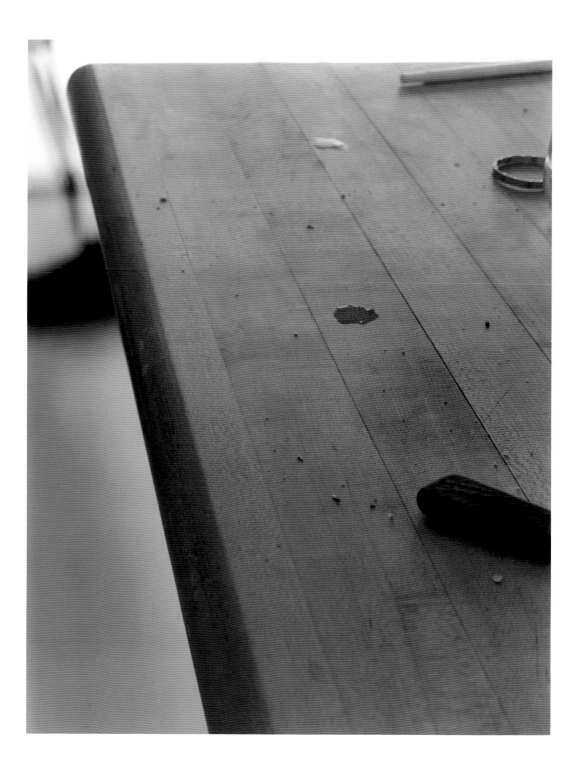

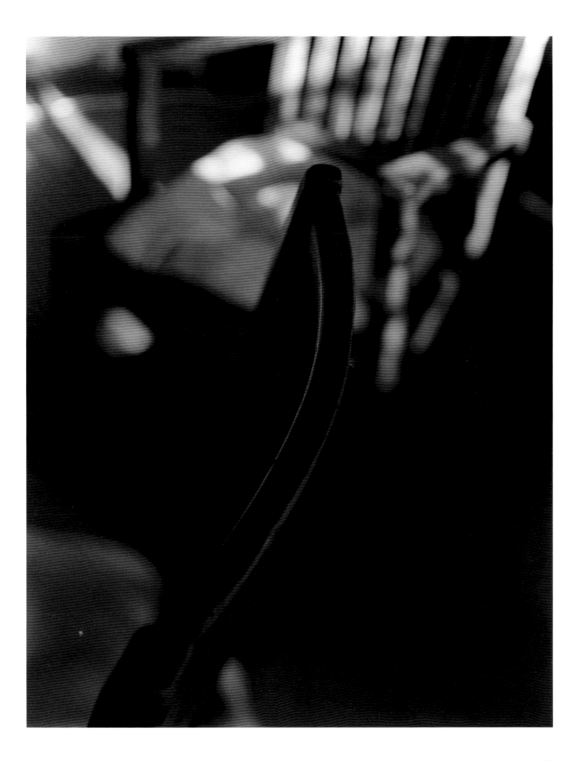

"The ache for home lives in all of us,
the safe place where we can go as we are
and not be questioned." maya angelou

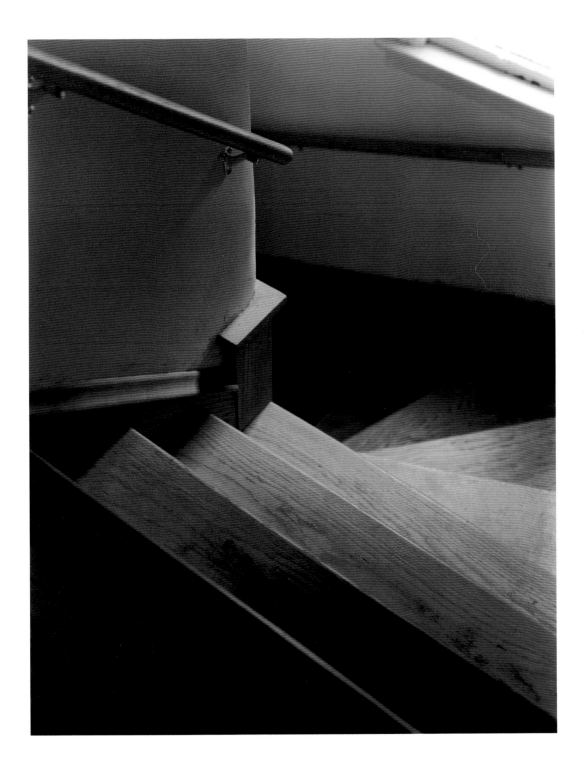

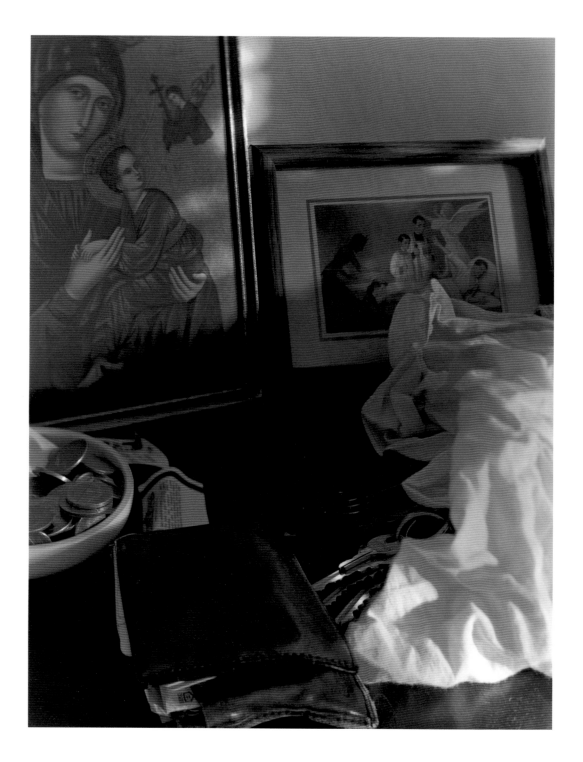

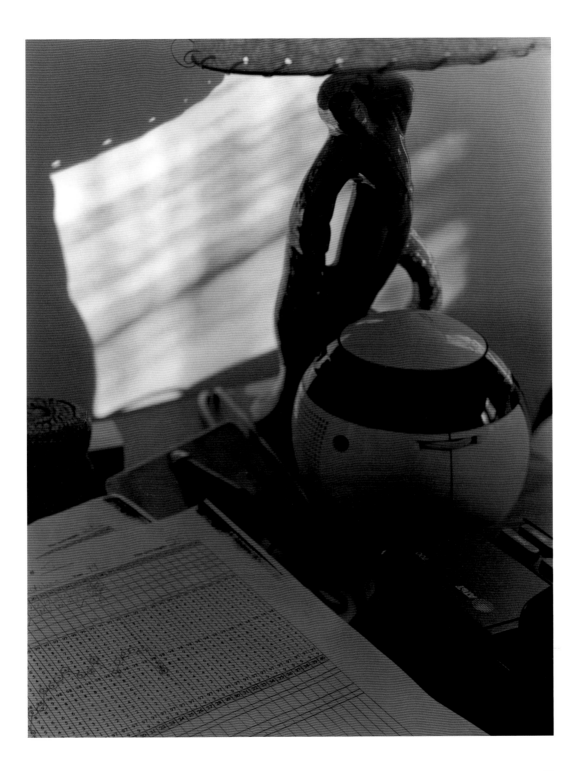

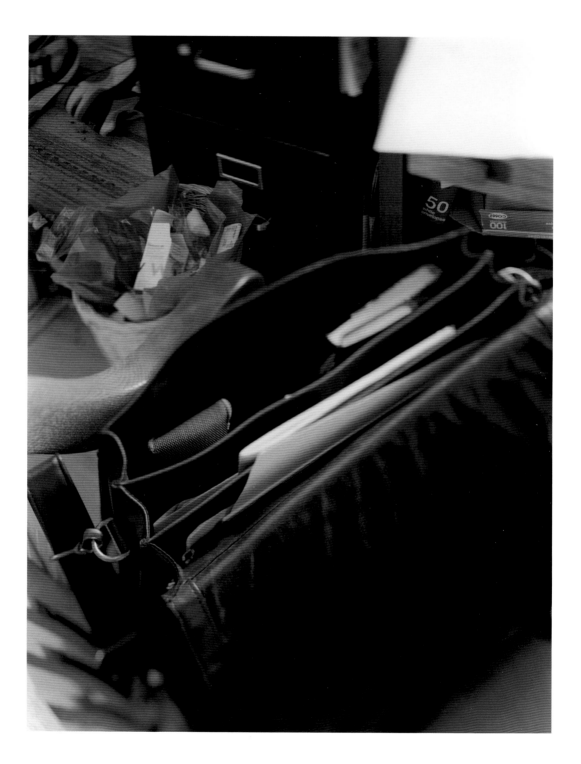

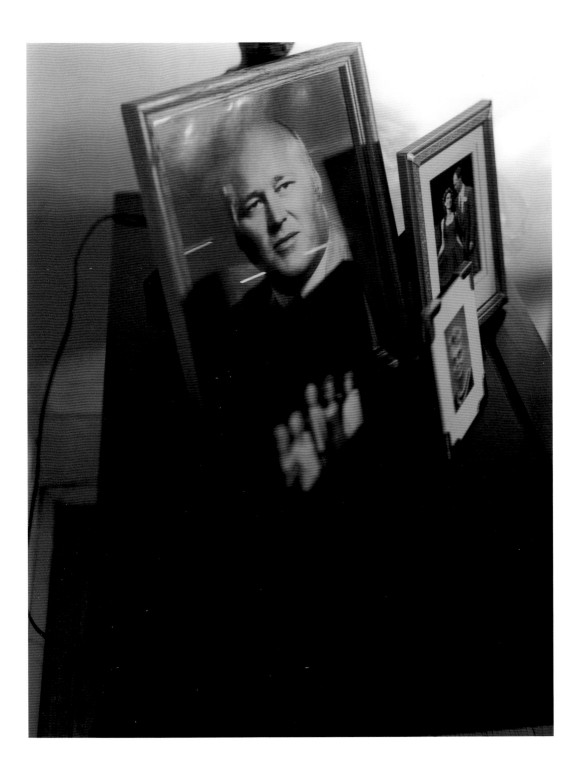

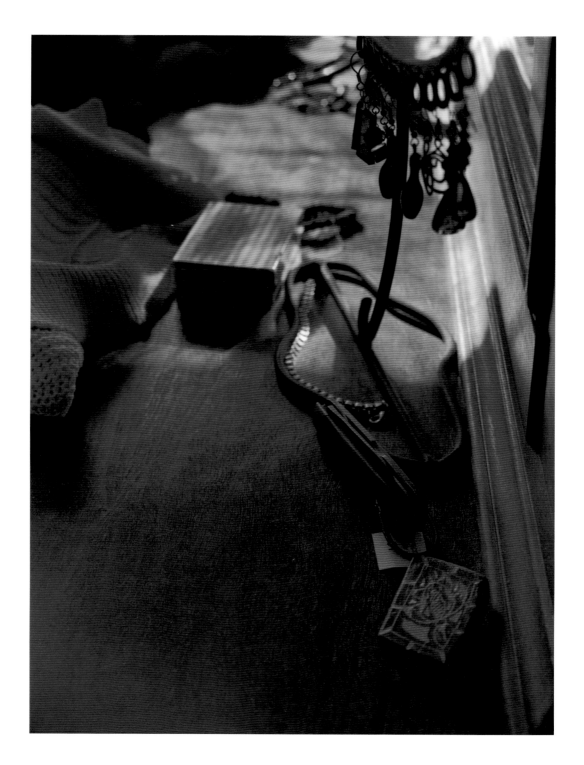

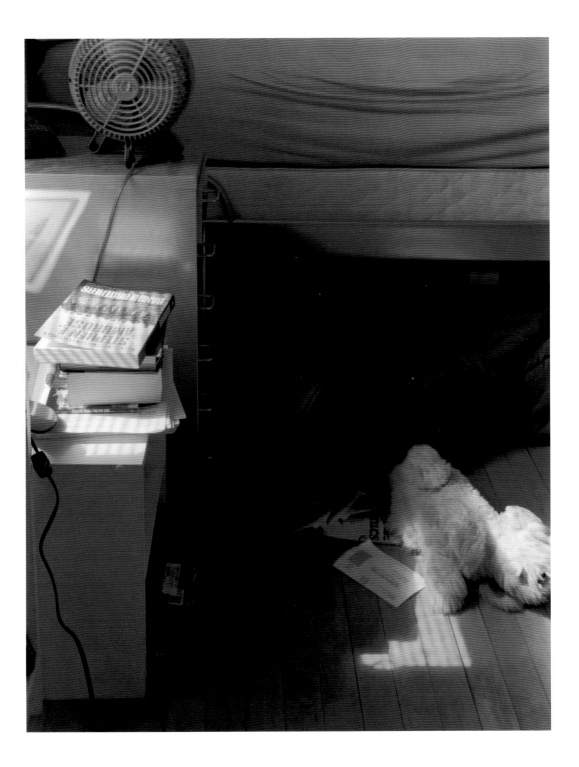

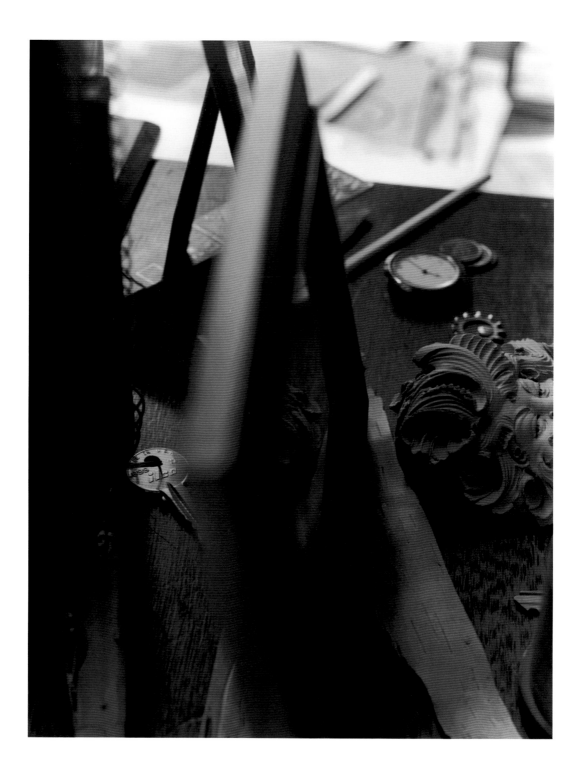

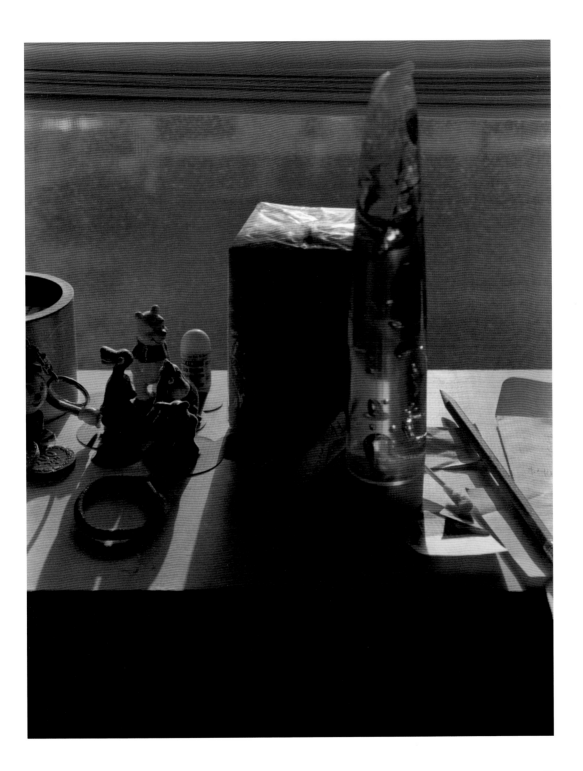

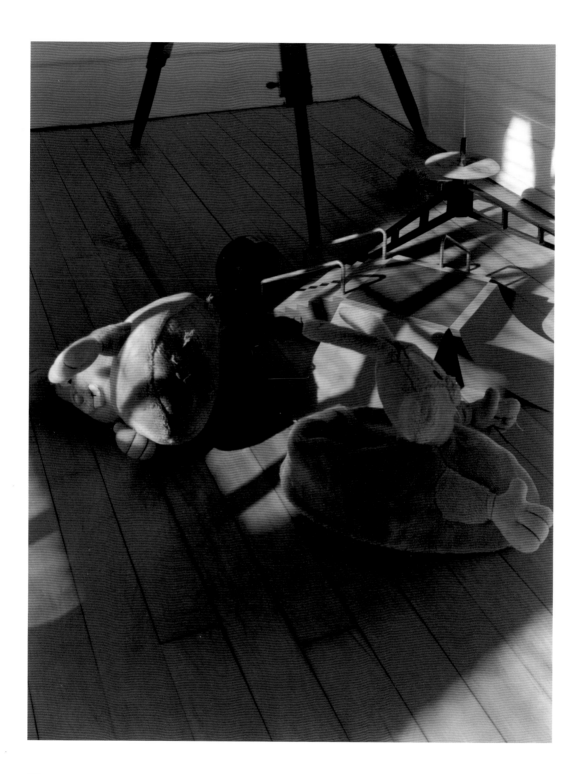

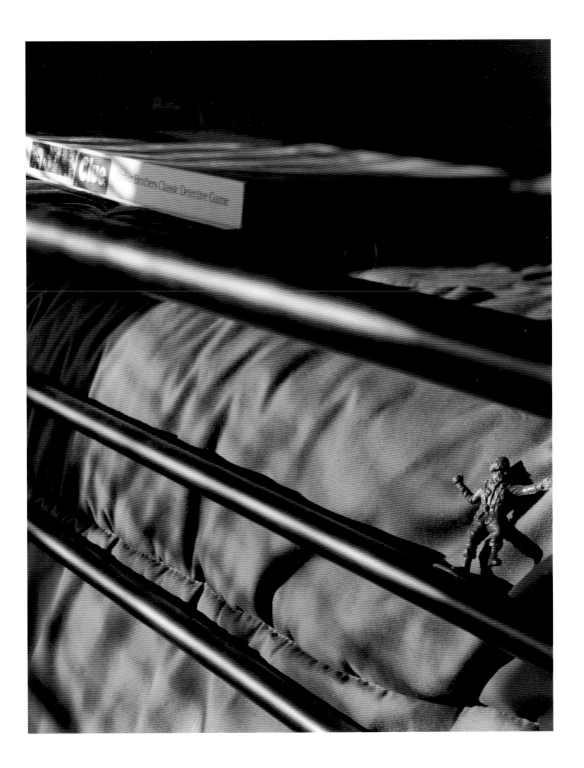

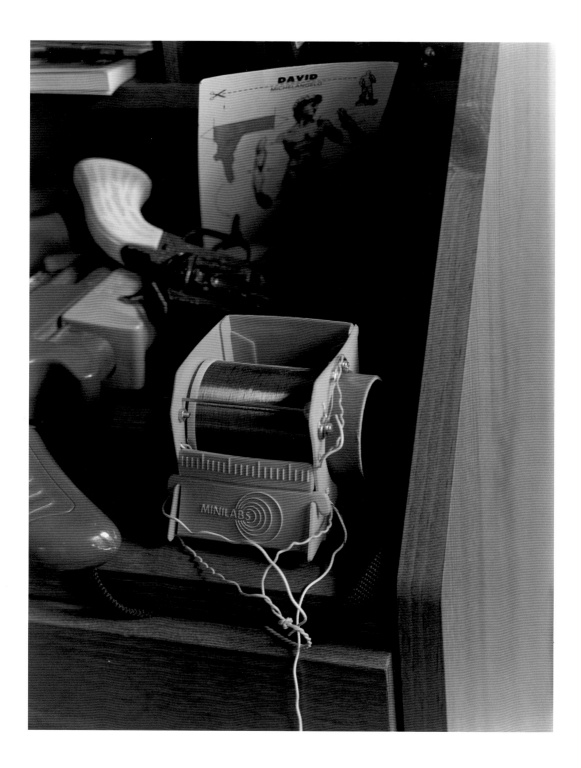

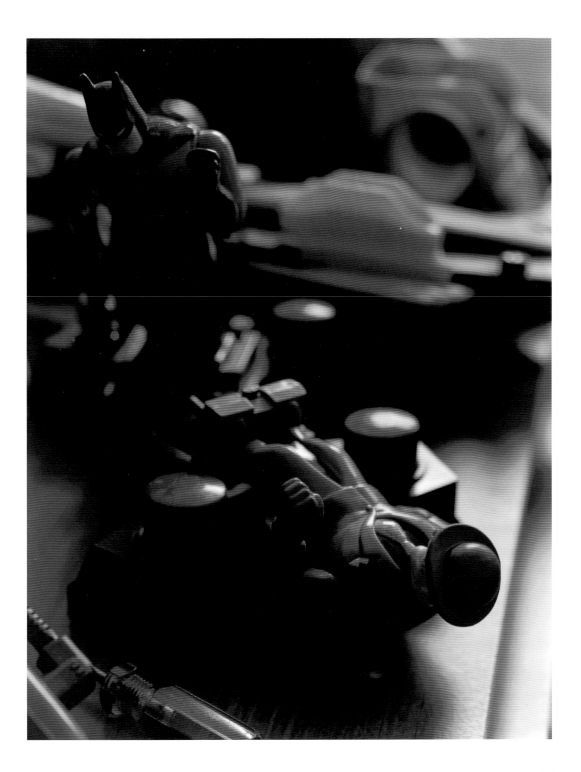

"The house never forgets the sound of its original occupants."

john hejduk

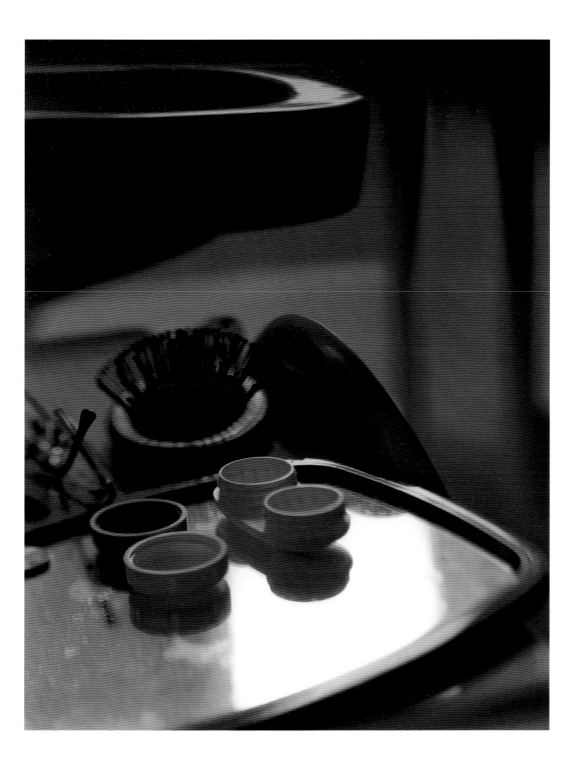

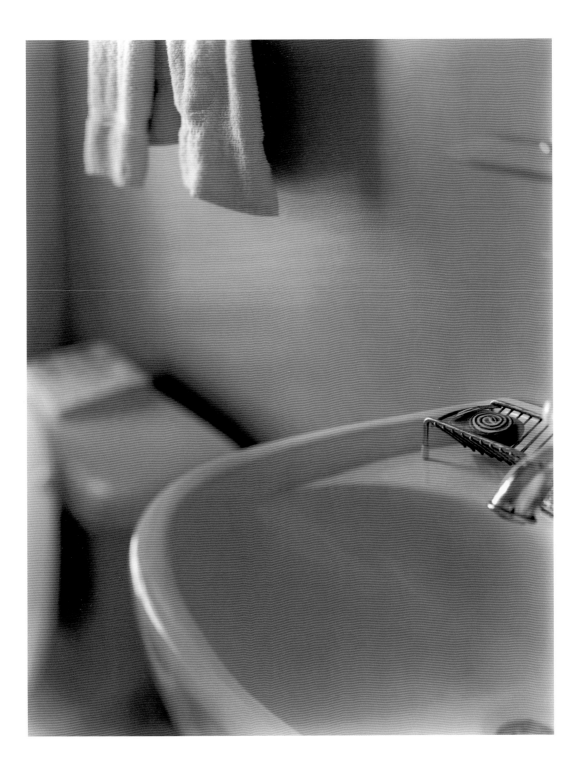

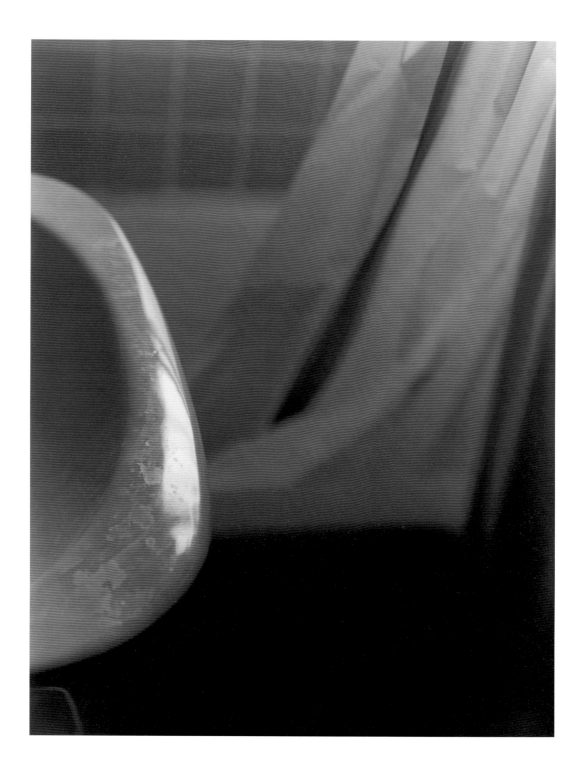

"Or perhaps it is
that the house only constructs itself
while we look—
opens, room from room, *because* we look.
The wood, the glass, the linens, flinging themselves
into a form at the clap of our footsteps."

jane hirshfield

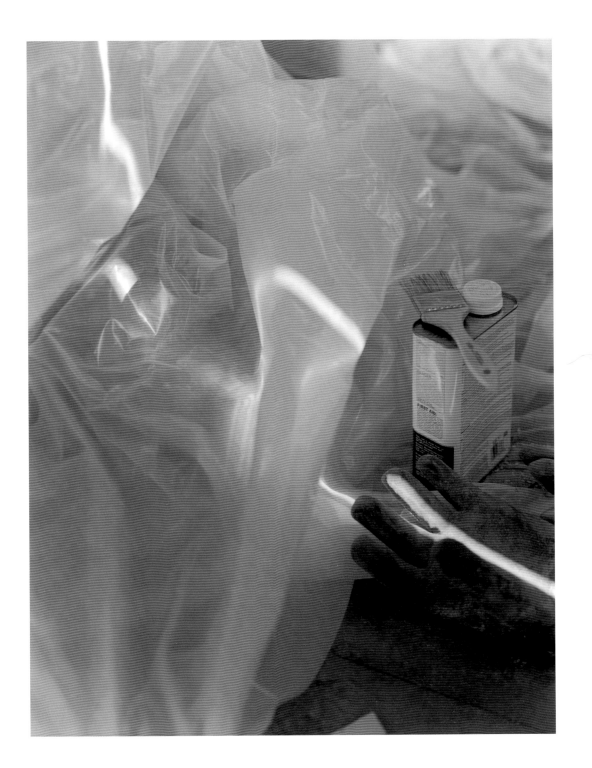

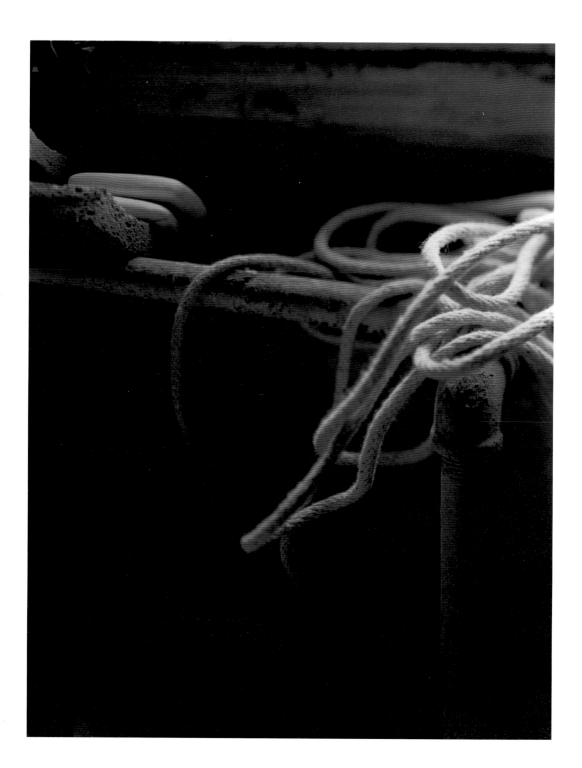

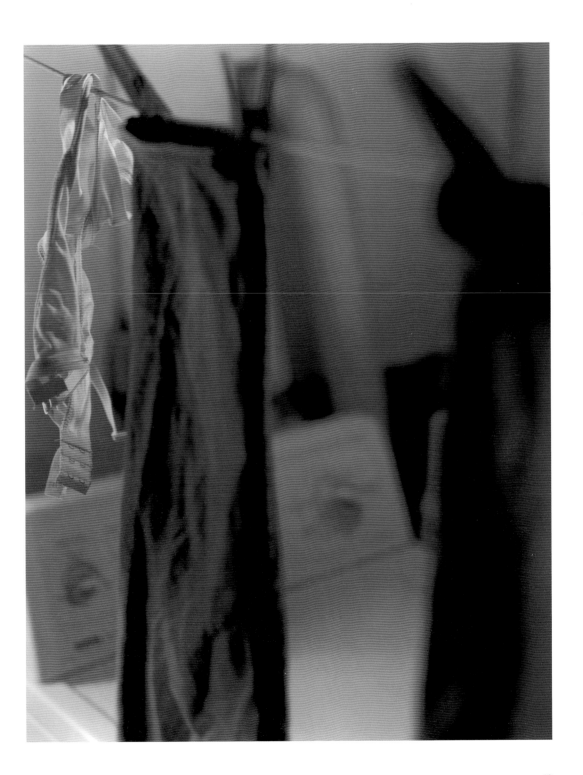

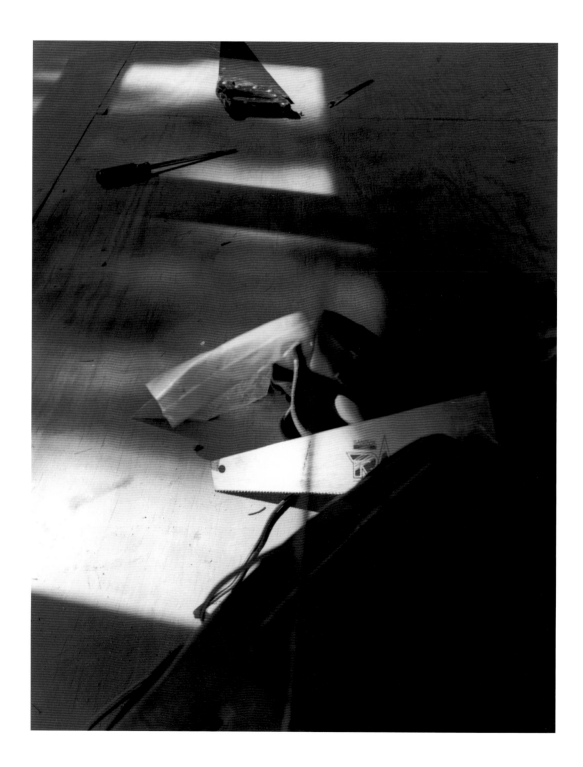

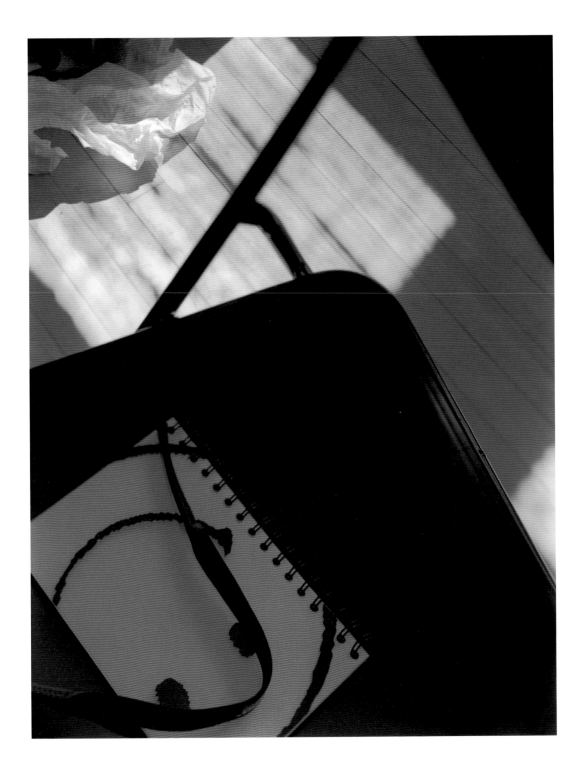

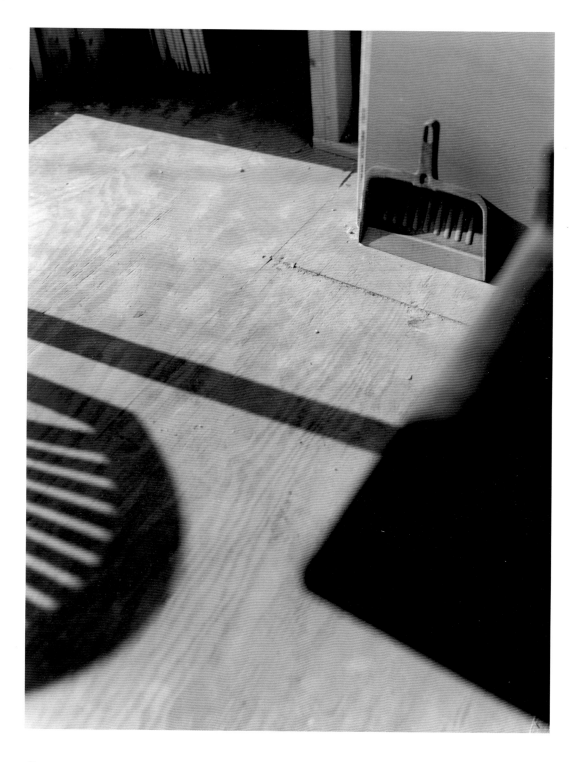

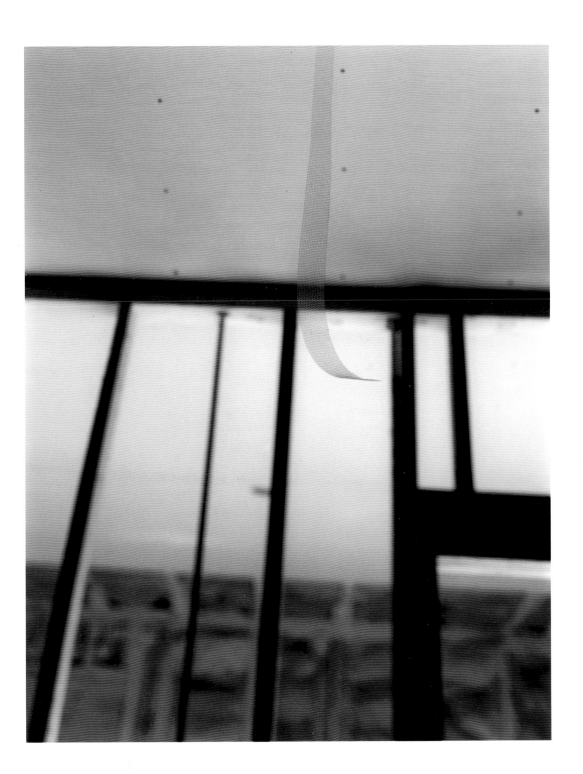

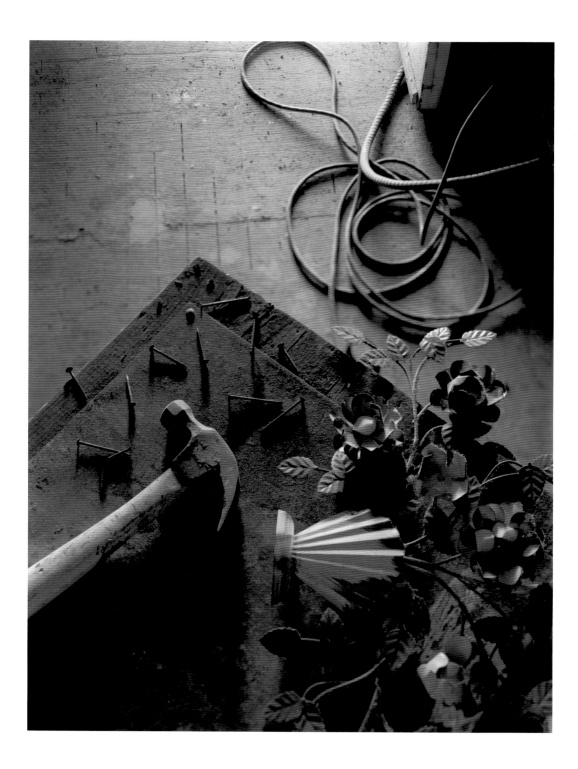

"The house settles down on its haunches
for a doze.
I know you are with me, plants,
and cats—and even so, I'm frightened,
sitting in the middle of perfect possibility."

jane kenyon

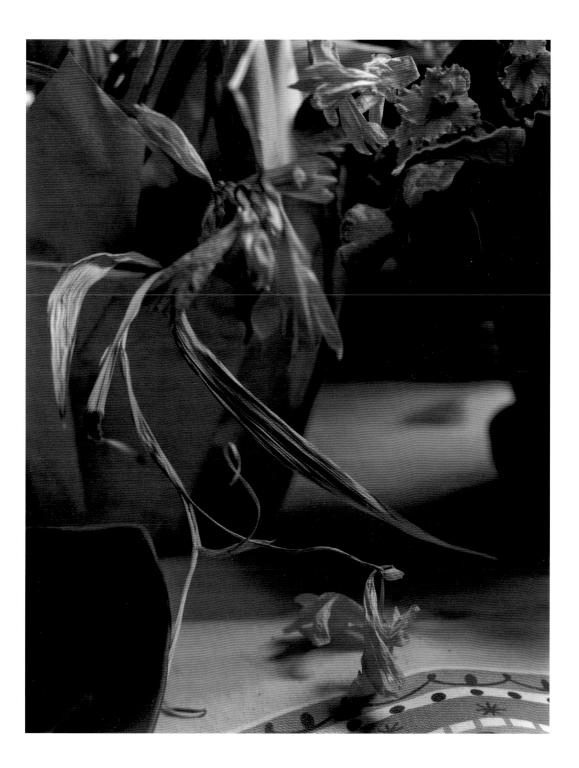

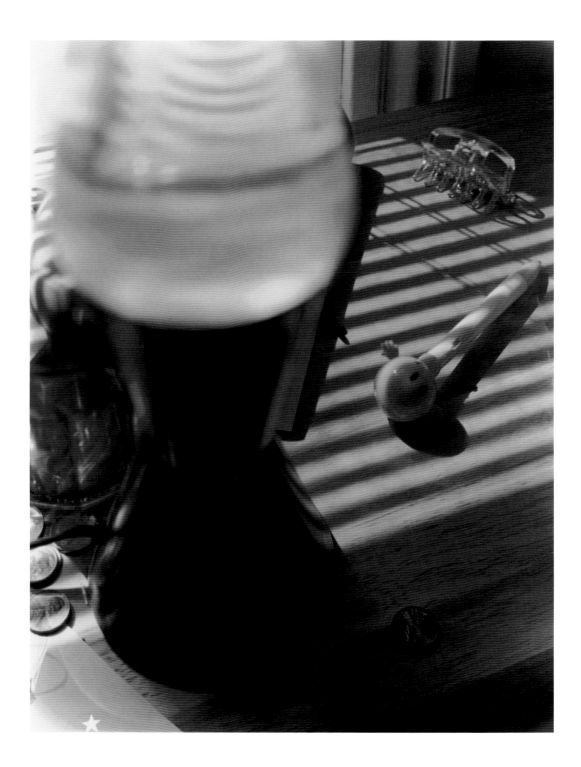

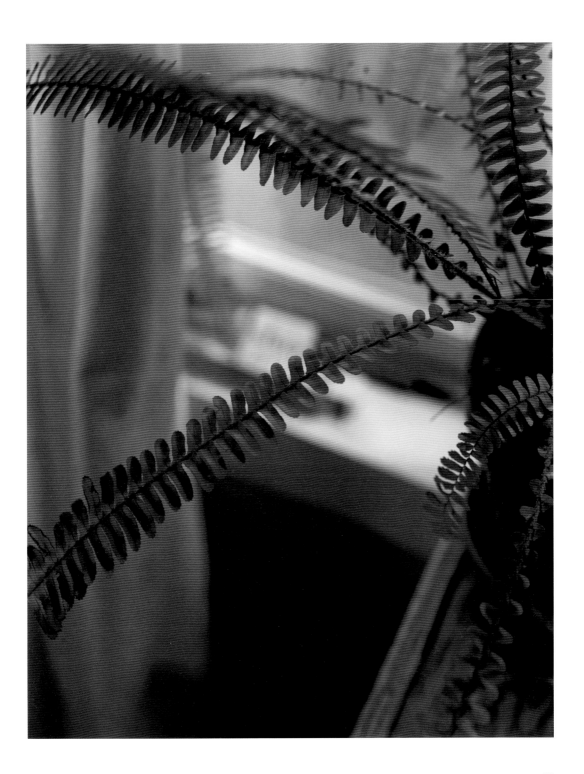

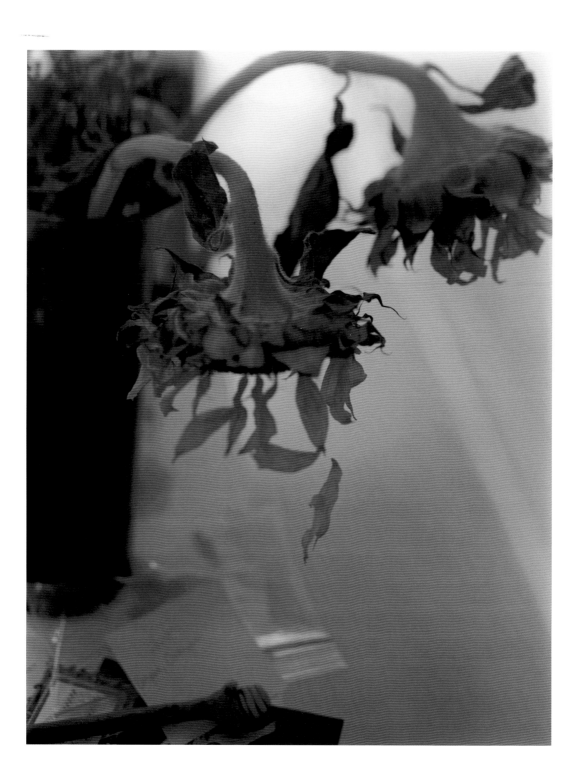

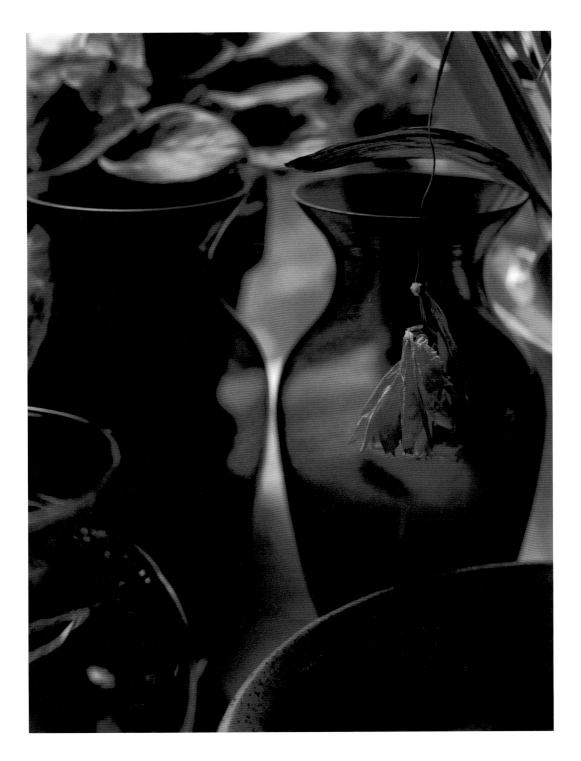

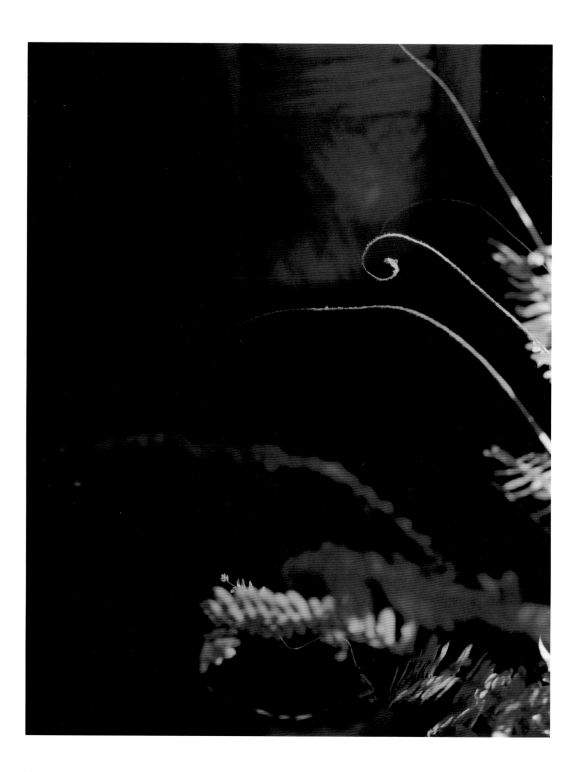

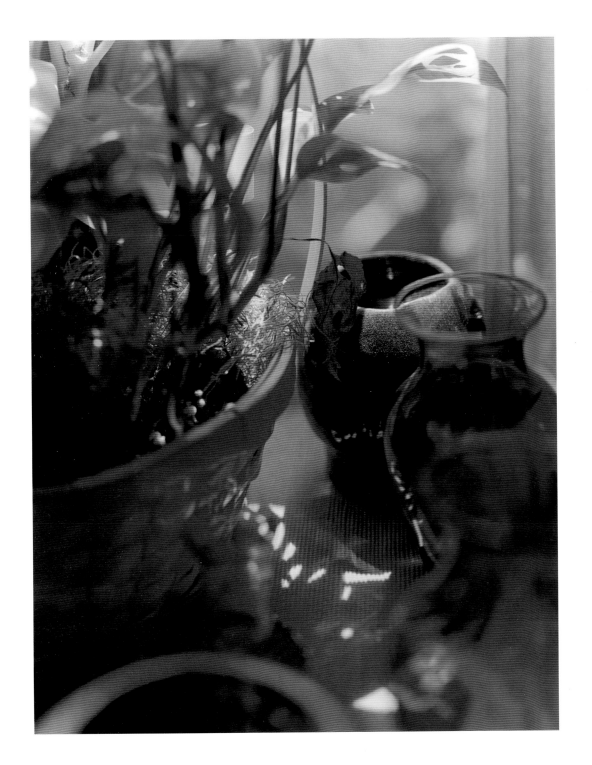

afterword: LIVING IN A FOURSQUARE

BRANDY SAVARESE

I don't know Bill Frederking personally, but I do know we share a remarkable set of similarities. To start, we both live in eighty-five-year-old American Foursquares located in long-established residential neighborhoods, his in an old suburb of Chicago and mine near a revived downtown. Our cities, Oak Park, Illinois, and Charlottesville, Virginia, are also well known as the homes and workshops of two renowned American architects—Frank Lloyd Wright and Thomas Jefferson, respectively. We both sought to find a house in which to make a home for our families, and so our houses mark starting points in our lives. My husband and I were married just weeks before finding our house on Booker Street; Frederking, after finding a new and larger home for himself and his two children,

fell in love and remarried while in the process of remodeling his home. For each of our families, "home-making" began with the purchase of an old house, but it has evolved to encompass more than just moving in and renovating. Home-making, after all, is about the process of defining your own life within the boundaries of your house and transforming that house into your home.

While Oak Park and Charlottesville are synonymous with the names of famous architects, they are also home to diverse residents, each seeking to define their place within the community. Few Americans are able to afford a house designed by an architect, let alone one by Frank Lloyd Wright or Thomas Jefferson. And yet the specter of these architects hangs heavy over towns such as ours. There is a long-running joke in Charlottesville that new development must be constructed of red bricks and white trim in keeping with the Jeffersonian style of the town dictated by the former president's designs for his home, Monticello, and the University of Virginia's Academical Village. Only recently has the city begun to break away from this trend, breathing

new architectural life into the built environment. Still, homes such as the four-square are commonplace in older neighborhoods where families such as mine and Frederking's find a place in the community.

Like Frederking and his children, my husband and I desired a home of our own to satisfy the physical and spiritual needs of more space and a fresh start. On our first day of house hunting, we visited a foursquare in the Rose Hill neighborhood. Steve and I left the house with mixed emotions; we liked it a lot, but were scared to take the plunge. I struggled to convince myself that it was a bad idea to buy the first house we liked, but I couldn't get the house on Booker Street out of my mind. I must have driven by it six times in the week following our first visit; each time I saw it I became more convinced that it was the house for us. I'm not sure if my own desire for a home compelled me to want the house, or if it was something in the house itself. As in Frederking's case, I like to think the house called out to us.

We became interested in the foursquare after seeing its photograph and description. Stylistically, it fit our prerequisite: we wanted a classic, early-twentieth-century house. The American Foursquare is a simple house—a truly American building type—developed in the early twentieth century in stark contrast to the heavily ornamented Victorian style of the late nineteenth century. Unlike the bungalow, its architectural contemporary, or its precedent, the Victorian, the foursquare was not adapted from the building styles of other countries. Indeed, the development of the foursquare is often attributed to the distinctly American Prairie Style houses of Frank Lloyd Wright. But the foursquare, composed of two stories, usually with four rooms on the first floor and four more directly above, are so simple that they are found in almost every town and city in the United States. The simple form was so easily adaptable to site, building material, and climate that the house became an integral part of the early-twentieth-century Sears & Roebuck homes available for sale across the country through its catalog.

Case in point: my foursquare is different from Frederking's in

that I have an open porch and side entry. His has an enclosed porch and a central hall. His foursquare is typically suburban, reflecting the early history of Oak Park as a wealthy suburb. My foursquare, on the other hand, was built with a side entry to minimize costs and to accommodate a narrow urban lot. Yet, despite minor stylistic differences dictated by site and taste, the Oak Park and Charlottesville foursquares share a common architectural lineage.

Steve and I were attracted to the simplicity of the layout of the foursquare and its presence on the street. Physically, the house was in decent condition and met our square-footage requirement. The price was attractive, too. We were shopping in a tight, increasingly expensive real estate market, where few listings fulfilled the majority of our requirements. This house seemed ideal—not too much renovation to take on, but enough to do to make it our own. In the week it took us to make our decision, I did some public records research on the house and the neighborhood. What I learned made the house even more appealing: only one family had owned and occupied our house since it was built in 1920. Like

Frederking's house, it came with a lot of history.

Descendents of the family still live in our neighborhood. In the hot real estate climate of renovating and flipping houses, the continuity of home ownership appealed to us. The foursquare on Booker Street had a history of nurturing a family and we felt that it would do the same for us. We looked forward to being its custodians and documenting our lives within its walls, much as Frederking has done with his home.

Frederking's elegant, still-life photographs deliver surprising hints of one family's life, providing a subtle but new perspective on home-making and home improvement, both psychologically and architecturally. They capture and convey what it feels like to settle in to a house, to live there, and to make it a safe, comfortable, and nurturing home.

We Americans have created a cult of the home. Witold Rybczynski described the idea of home-making long before the real estate boom of the past decade: "'Home' brought together the meanings of house and house-

hold; of dwelling and of refuge, of ownership and affection. 'Home' meant the house, but also everything that was in it and around it, as well as the people, and the sense of satisfaction and contentment that all these conveyed."*

Now large sections in national bookstores are dedicated to books and periodicals that reinforce the cult of the home. These publications serve a dual purpose: functionally, they are up-to-date resources for homeowners and home-improvers, while, psychologically, they serve as a "support group" in which the reader learns about others involved in familiar endeavors, providing encouragement, inspiration, and education for people who seek to define their own notions of home and carve out a place for their families in the community.

Frederking's strikingly private photographs document a time and place unique to his life. To his credit, this powerful collection of personal images could also easily be of my home, and of my process of home-making. Frederking's photographs allow us to see the most intimate aspects of home and how a family endeavors to make one.

* Witold Rybczynski, *Home: A Short History of an Idea* (New York: Viking, 1986), page 62.

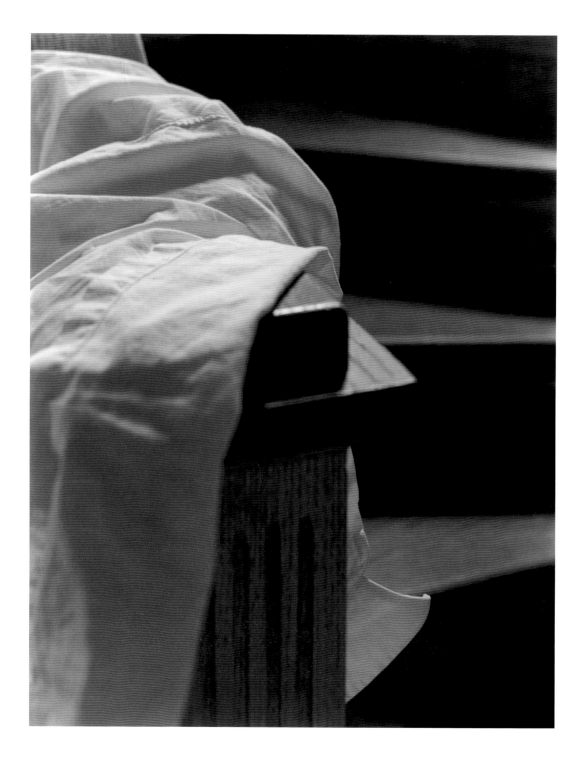

acknowledgments

I wish to thank the many people who, through their friendship and support, have made possible the publication of this, my first book. I am especially grateful to Bob Thall, chairman of the Photography Department at Columbia College Chicago, my friend and colleague of more than twenty years, without whom this book might never have happened. He has been a helpful critic and supporter of my work for as long as I have known him. Bob first showed these photographs to his friend and editor of his books, George F. Thompson, president and publisher of the Center for American Places. George's response to the photographs was extremely positive, thoughtful, and supportive. His insights into the work allowed me to see my own work more clearly and enabled me to make more photographs and complete the book. Both Bob and George were tremendously patient and helpful as we began to edit the photographs and lay out the sequence of the book, and they continued their help and support throughout the project, from beginning to publication. I feel very lucky to know and to work with two such gracious and generous people.

I am most grateful for the unexpected and wonderful support from Mark Kelly and Patricia Needham and Terri Reinartz. As I began to make these photographs, several other key people were willing to look at the work and provide me with honest and beneficial critique. I am especially grateful to my wife, Donna Mandel, and my friends Garnett Kilberg Cohen, Bill Friedman, Karen Glaser, Jennie Halliday, Paul Hoover, Tim Long, and Jocelyn Nevel. During the preparation of the mock-up for the book, I

received much-needed and generous technical digital assistance from my friend and teacher, Tammy Mercure. I also thank Denise Miller, John Mulvany, and Bert Gall, early supporters of my photography, for their friendship and wisdom over many years.

Columbia College Chicago has been my employer and a strong and generous supporter of my photography. I have received three faculty development grants that provided financial support for this and many other projects since 1983. I thank Dr. Warrick Carter, President; Steven Kapelke, Provost; Leonard Lehrer, Dean of the School of Fine and Performing Arts; and Michael DeSalle, Chief Financial Officer; for their continuing support.

I wish to thank Brandy Savarese for connecting with my photographs and contributing the accompanying essay. I would also like to thank the many people who worked on the production of this book: Colleen Plumb, for her sensitive design; Ben Gest, for his skillful preparation of the digital files; Christine DiThomas, for her thoughtful copyediting; Amber K. Lautigar, for her assistance as the Center's publishing liaison; and Steini Torfason and his colleagues at Oddi Printing, for their fine presswork.

credits

The quotations that I share in this book appeared in the following publications:

James Agee and Walker Evans, *Let Us Now Praise Famous Men:*
Three Tenant Families
(Boston: Houghton Mifflin, 1969)
Copyright 1941 by James Agee and Walker Evans.
Copyright © renewed 1969 by Mia Fritsh Agee and Walker Evans.
Reprinted by permission of Houghton Mifflin.
All rights reserved.

Maya Angelou, *All God's Children Need Traveling Shoes*
(New York: Random House, 1991)

John Hejduk, "Sentences on the House and Other Sentences,"
in *Such Places as Memory: Poems 1953–1996*
(Cambridge, Mass.: MIT Press, 1998)

Jane Hirshfield, "The House In Winter," in *The October Palace*
(New York: HarperCollins Publishers, Inc., 1994)

Jane Kenyon, "Afternoon in the House," in *From Room To Room*
(Farmington, Maine: Alice James Books, 1978)

I am indebted to the publishers for the permission to use them.

William Frederking was born in 1955 in Effingham, Illinois, and he moved to Chicago in 1977 after he received a B.A. in English from the University of Notre Dame. He completed his M.F.A. in photography from the University of Illinois at Chicago in 1983. He has been a professional photographer of dance since 1989, and currently is a professor of photography at Columbia College Chicago. His photography has been published in *The New York Times, Chicago Tribune, Chicago Magazine, Chicago Reader, Dance Magazine, Dance Teacher Magazine,* and *View Camera Magazine* and is included in several books about dance and dance education, including *Harnessing the Wind: The Art of Teaching Modern Dance* (Human Kinetics, 2003) by Jan Erkert. His work is in the permanent collections of the State of Illinois Museum and the Museum of Contemporary Photography, in Chicago, as well as private collections.

Brandy Savarese has known many homes in her life. She was born in 1977 in Panama to military parents and subsequently lived in Washington, D.C., North Dakota, New Mexico, Turkey, and South Carolina. Savarese received a B.A. in Italian and art history from the University of Georgia and completed an M.A. in architectural history at the University of Virginia under Richard Guy Wilson. She makes her living as an editor and freelance writer from her home in Charlottesville, Virginia.

about the book

The photographs in *At Home* were made from 1996 to 2005. The text for *At Home* was set in Berthold Akzidenz-Grotesk and Bembo. The paper is acid-free Silk Gallery, 170 gsm weight. The tri-tone separations, printing, and binding were professionally rendered by Oddi Printing Ltd., of Reykjavik, Iceland. *At Home* was published in association with the Photography Department at Columbia College Chicago, which is one of the nation's largest and most prestigious photography programs. For more information, visit online at: www.colum.edu/undergraduate/photo.

FOR THE CENTER FOR AMERICAN PLACES:

George F. Thompson, President and Publisher

Amber K. Lautigar, Publishing Liaison and Associate Editor

FOR COLUMBIA COLLEGE CHICAGO:

Christine DiThomas, Manuscript Editor

Colleen Plumb, Book Designer

Mary Johnson, Director of Creative and Printing Services

Benjamin Gest, Director of Digital Scans

Jennifer Keats, Digital Imaging Assistant

Tammy Mercure, Digital Imaging Facilities Coordinator

Thomas Shirley, Coordinator of Digital Imaging

Bob Thall, Chairman, Photography Department